Contents

Fun with Collage!

You can have lots of fun with collage! Collage is a kind of art where you use lots of things, such as fabric, paper and beads, to make a picture. This is what you will need:

- Card
- Cotton wool balls
- Beads, sequins, pebbles and shells
- Dried peas and beans
- Felt
- Magazines
- Fabric

- Paper
- Pasta shapes
- Plain bag
- Small box with a lid
- Tissue paper
- Twigs

Note for adults
Children may need adult assistance with some of the project steps.
Turn to page 23 for Further Ideas.

Read the 'You will need' boxes carefully for a full list of what you need to make each project.

Before you start, ask an adult to:

• find a surface where you can make the projects.

• find an apron to cover your clothes, or some old clothes that can get messy.

• do things, such as cutting with scissors, that are a little tricky to do on your own.

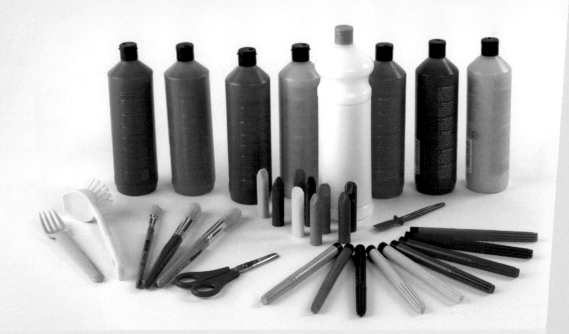

Feathered Friend

Create a beautiful bird with lots of patterned feathers!

You will need
- 1 sheet of paper
- 1 sheet of coloured card
- Wax crayons
- Plastic fork
- Paintbrush
- Pencil
- Poster paints – black
- PVA glue
- Scissors

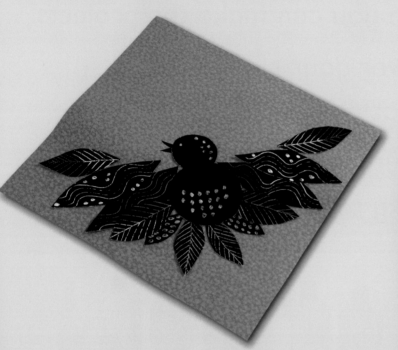

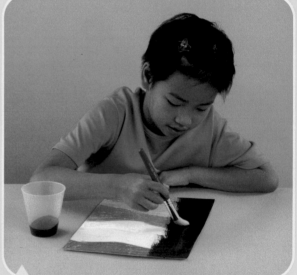

1 Cover the whole sheet of paper with wax crayon patterns using lots of bright colours.

2 Paint thick black paint all over the paper and leave to dry.

3 Draw a small circle, a large circle and feathers of different shapes and sizes on the paper. Cut them out.

4 Using the fork, scratch patterns in the cut-out shapes so the colours show through.

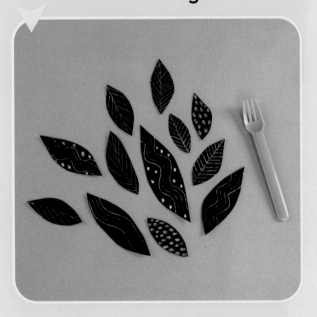

5 Glue the circles and the feathers onto coloured paper to make a bird.

 Ask an adult for help with cutting paper!

Modern Art Picture

Have fun making one face from lots of different faces!

You will need
- Magazines
- 1 sheet of paper
- Pencil
- PVA glue
- Scissors

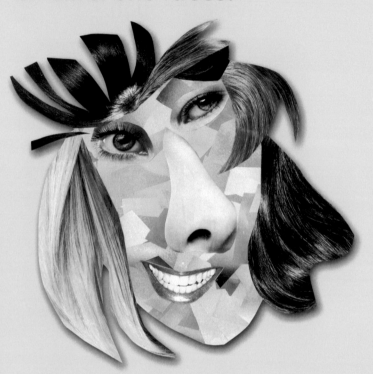

1 Look through magazines for photos of people's heads and faces, and cut them out.

2 Draw an outline of a face on the paper.

3 Cut some of the magazine photos into small pieces and glue them all over the face. Do not glue over the edges!

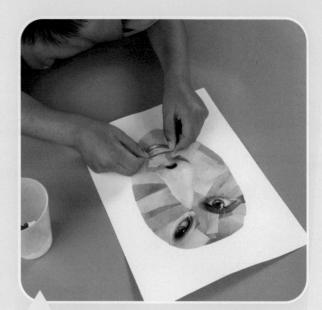

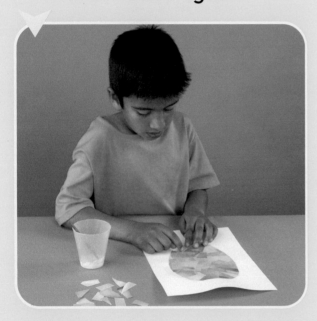

4 Cut a nose, a mouth and eyes from one or more of the photos, and glue them onto the face.

5 Cut hair from one or more of the photos and glue it onto the face to finish your picture.

 Ask an adult for help with cutting paper!

A Plate of Food!

Use lots of different dried foods to make a picture.

You will need
- Pasta shapes
- Dried peas and beans
- 1 sheet of white card
- Felt-tip pens
- Pencil
- PVA glue
- Scissors

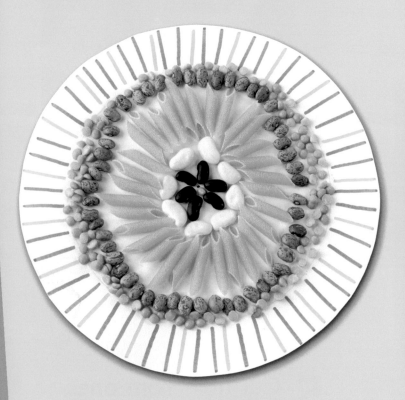

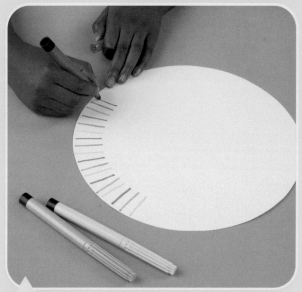

1 Draw a circle on the card and cut it out to make a plate.

2 Decorate the edge of your plate using felt-tip pens.

3 Glue a split pea into the middle of the plate.

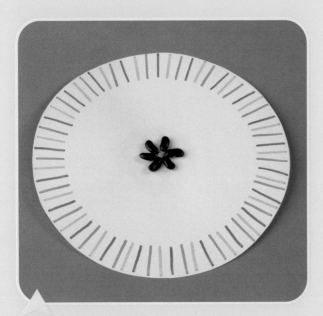

4 Glue dried beans around the split pea in a circle.

5 Keep making circles by glueing on beans, pasta and split peas until you reach the decorated edge of the plate.

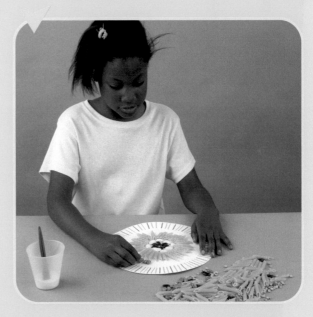

 Ask an adult for help with cutting card!

Treasure Chest

A special place to keep
your treasure.

You will need
- 1 small box with lid
- Foil trays
- Kitchen brush
- 1 large sheet of paper
- Poster paints
- PVA glue

1 Pour different
coloured paints
into foil trays.

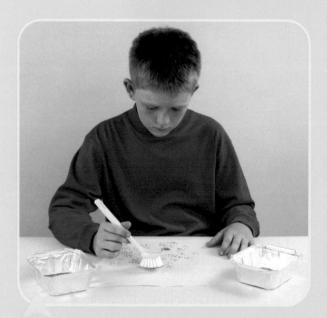

2 Dip the kitchen brush
lightly into one of the
paints and splatter it
onto the paper.

3 Repeat with different colours and leave to dry.

5 Glue the pieces all over the box and lid to decorate your treasure chest.

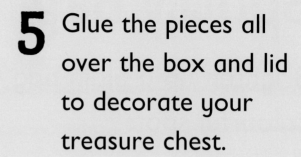

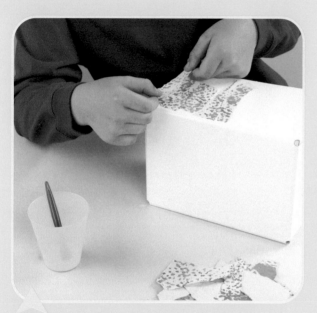

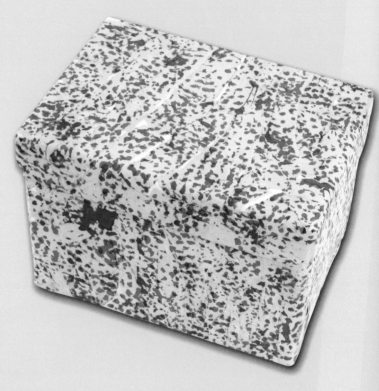

4 Tear up the painted paper into small pieces.

Spotty Bag

Brighten up a plain bag with colourful spots!

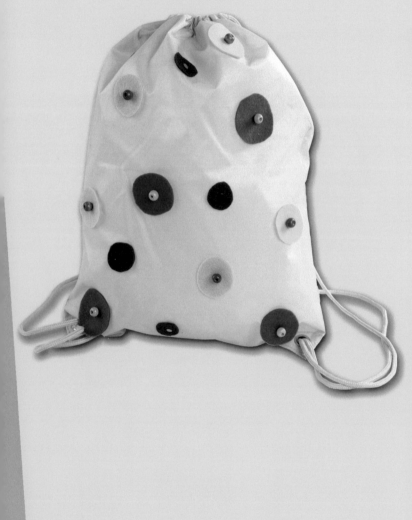

1 Cut out circles in different sizes from the pieces of material and the felt.

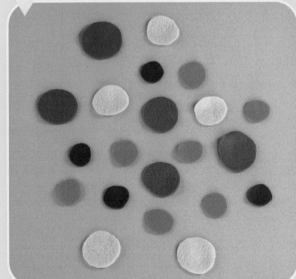

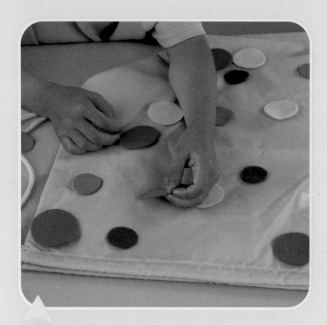

2 Place the circles onto one side of the bag to make a pattern.

3 Glue into place and leave to dry.

4 Repeat steps 2 and 3 on the other side of the bag.

5 Glue beads and sequins onto the middle of each of the circles, and leave to dry.

 Ask an adult for help with cutting material!

Under the Sea

Pretend that you are a diver as you create this underwater scene.

You will need

- Felt in different colours
- Sequins
- Pebbles or shells
- 1 sheet of blue card
- Coloured paper
- Fabric glue
- Felt-tip pens
- Pencil
- PVA glue
- Scissors

1 Draw fish in different shapes and sizes on felt and coloured paper, and cut out.

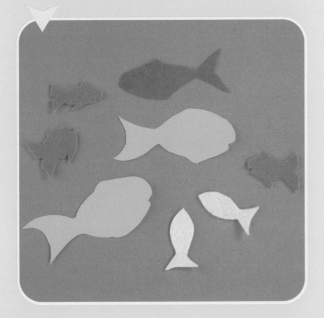

2 Glue sequins onto the felt fish and draw patterns on the paper fish.

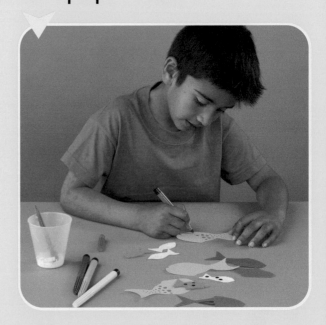

4 Glue the fish onto the card.

5 Glue pebbles or shells onto the sea bed.

3 Cut out plant shapes from felt or paper, and glue onto the card.

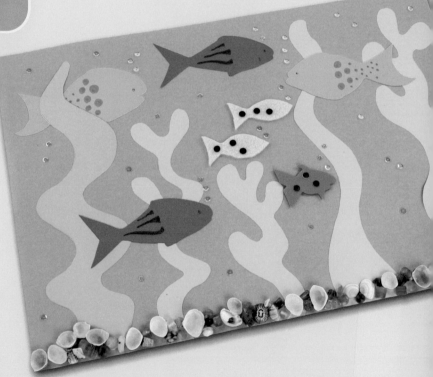

 Ask an adult for help with cutting felt and paper!

Lush Green Trees

Go back to nature with snowy mountains and amazing trees!

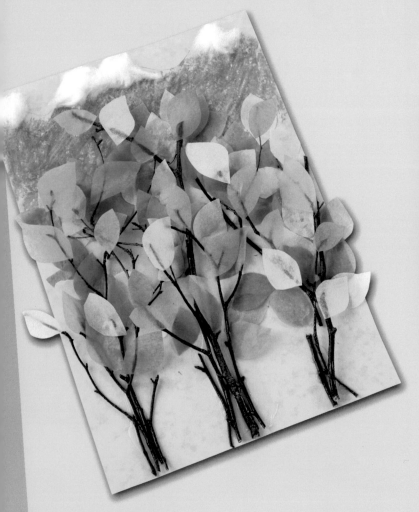

1 Draw and colour mountains on the top half of the card, right to the top.

2 Open out the cotton wool balls a little bit, and glue them onto the mountains to make snow.

3 On the bottom half of the card, draw trees of different shapes and sizes.

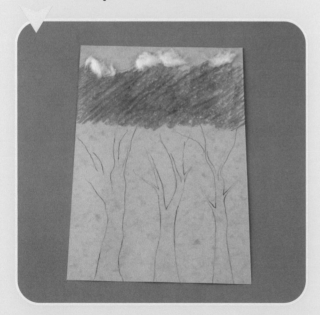

4 Glue small twigs all over the tree trunks. Use some twigs for branches too.

5 Cut leaf shapes from green tissue paper and glue them onto the trees.

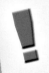 Ask an adult for help with cutting tissue paper!

Stained-Glass Window

Watch the sun shine through this pretty stained-glass window!

1 Fold the paper circle in half, then in half again and then in half again.

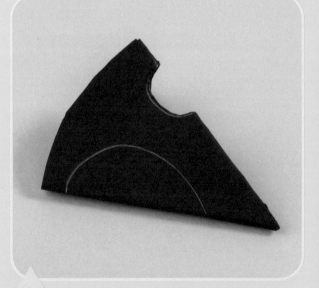

2 Draw shapes on the edges of the paper wedge. Cut the shapes out and open to make a window.

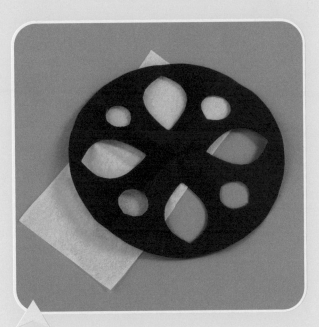

4 Trace the shapes in the window onto the tissue paper. Cut out the paper shapes. Leave a small gap around the outside of the shapes as you cut.

3 Lay the window on top of a sheet of coloured tissue paper.

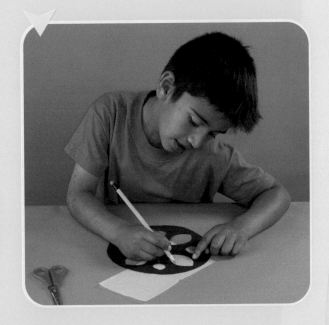

 Ask an adult for help with cutting paper!

5 Glue the tracing paper shapes onto the back of the window shapes so the colour shows through.

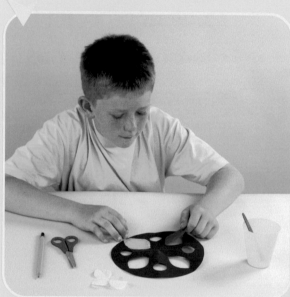

6 Repeat steps 4 and 5 using different coloured tissue paper until the window is full of different colours.

7 Leave to dry and then hang in a window so the light shines through.

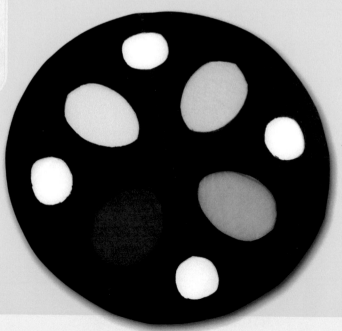

Further Ideas

Once a child has finished the projects in *Having Fun with Collage*, they can add some other exciting finishing touches to them.

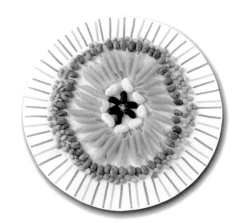

Feathered Friends
Dab PVA glue onto the bird, sprinkle glitter onto it and then shake off the excess glitter.

Modern Art Picture
Glue other cut-out pictures from magazines onto the portrait, such as earrings or a hat.

A Plate of Food!
Spray the picture with hairspray to make it shiny.

Treasure Chest
Glue beads and sequins to the chest so it looks precious on the outside too!

Spotty Bag
Make bows with colourful ribbon and glue them onto the bag.

Under the Sea
Cut out pictures of swimmers or divers from magazines and glue them onto the scene.

Lush Green Trees
Dab PVA glue onto the trees and mountains, sprinkle white or silver glitter onto the glue and then shake off the excess glitter.

Stained-Glass Window
Glue colourful sequins onto the black paper to make the window even prettier!

Further Information

With access to the Internet, you can check out several helpful websites for further arts and crafts ideas for young children.

www.bbc.co.uk/cbeebies/artbox/makeit/
www.kinderart.com
www.craftplace.org
www.dltk-kids.com/animals/metiger.html
www.craftown.com

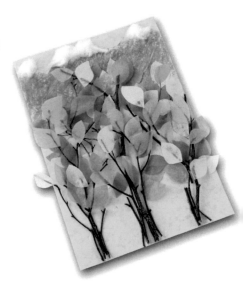

Glossary

collage sticking items onto a background to make a picture

felt thick, woollen material which is easy to cut and does not fray at the edges

scene a view of a place

stained glass decorative, coloured glass used in picture windows (especially in old buildings such as churches)

tissue paper thin, almost transparent craft paper

Index